Of Love & Sea Glass

Donald Verger

Of Love & Sea Glass
First Edition 2013

©2013 Donald Verger Photography
All Rights Reserved

Donald's camera of choice for this book was the iPhone® 5.

DonaldVerger.com
info@DonaldVerger.com

ISBN: 978-0-9895283-0-6
Cataloging-in-Publication Data may be obtained from the Library of Congress.

10 9 8 7 6 5 4 3 2 1

Published by Donald Verger Photography
Design by ClarksDesignServices.com

Printed and Bound in the U.S.A.
The paper used in the printing of this book was purchased from an FSC-certified mill.

Dedicated to

Dan Cheever
my mentor and dear friend

Eileen Skinner
for her friendship and support

With love and affection for

Rob and Carolyn

Mom and Dad

Lois, Laurie, Stacey, Chris

Kate's girls, Bayla and Devi

Being deeply loved by someone gives you **strength**, while loving someone deeply gives you **courage**.

— Lao Tzu

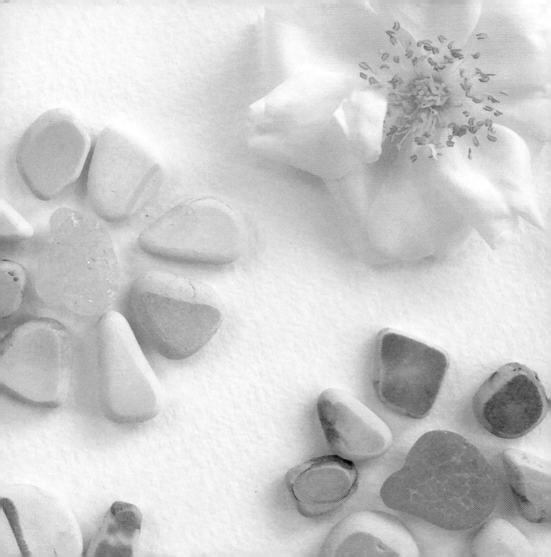

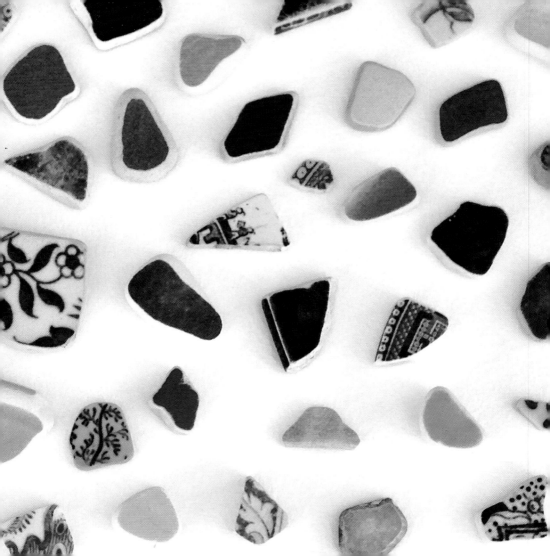

One doesn't **discover** new lands without consenting to lose sight of the shore for a very long time.

— André Gide, *Les Faux-monnayeurs (The Counterfeiters)*

We know only too well
that what we are doing is
nothing more than a drop
in the ocean. But if the
drop were not there, the
ocean would be missing
something.

— Mother Teresa

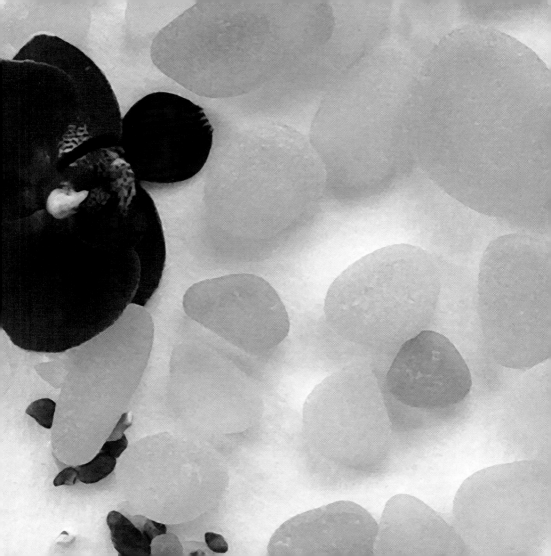

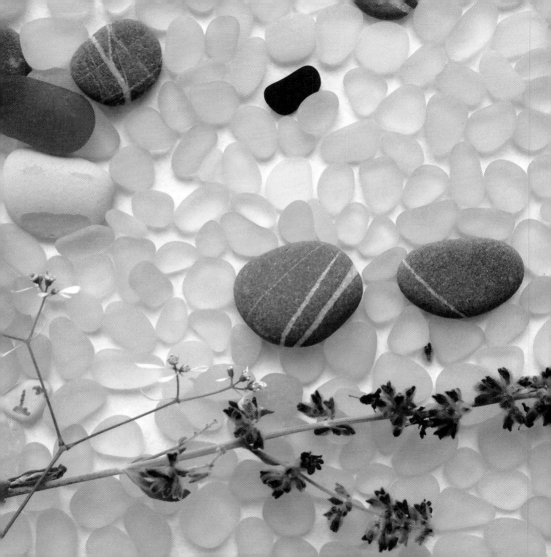

You know you're in **love** when you can't fall asleep because reality is finally better than your dreams.

— Dr. Seuss,
 From Personal Interview

Till my soul is full of longing
For the secret of the sea,
And the heart of the great ocean
Sends a thrilling pulse through me.

— Henry Wadsworth Longfellow,
 The Seaside and the Fireside

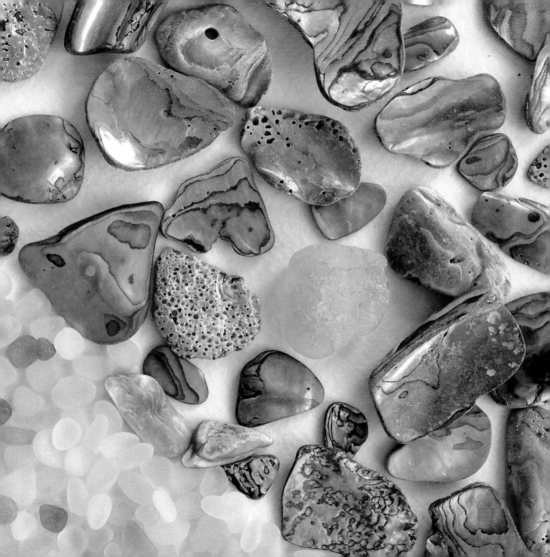

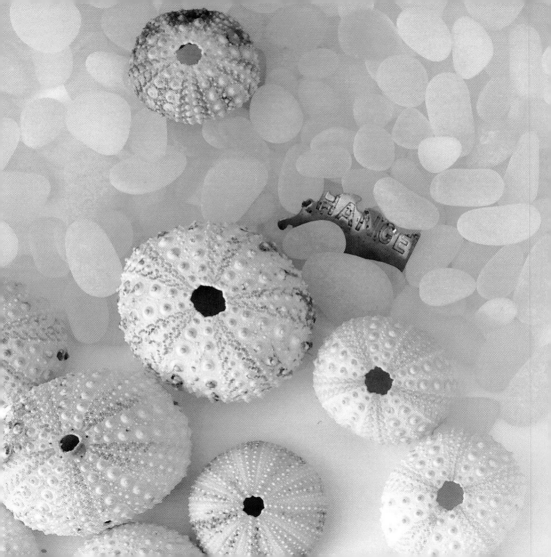

Because there's nothing more **beautiful** than the way the ocean refuses to stop kissing the shoreline, no matter how many times it's sent away.

— Sarah Kay, *"B"*, *If I should have a daughter...*

What is any ocean but a multitude of drops?

— David Mitchell, *Cloud Atlas*

Just like a sunbeam can't separate itself from the sun, and a wave can't separate itself from the ocean, we can't separate ourselves from one another.

We are all part of a vast sea of **love**, one indivisible divine mind.

— Marianne Williamson, *A Return to Love*

A woman's **heart** is an ocean of deep secrets.

— James Cameron, James Cameron's *Titanic*

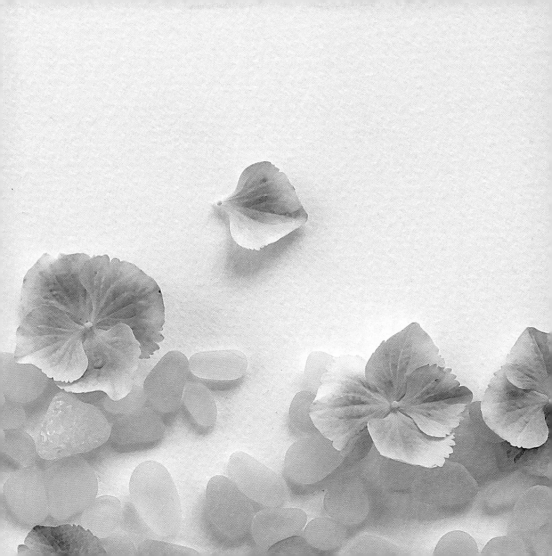

Everyone has oceans to fly, if they have the heart to do it. Is it reckless? Maybe. But what do **dreams** know of boundaries?

— Amelia Earhart

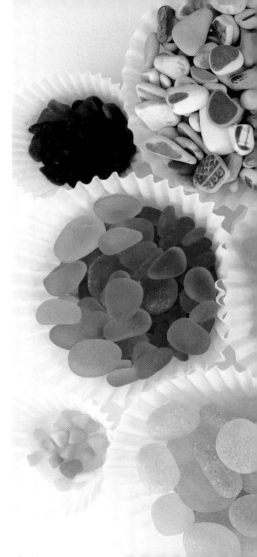

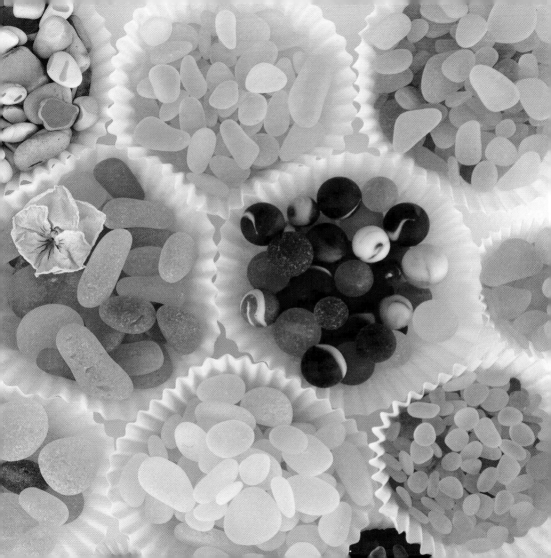

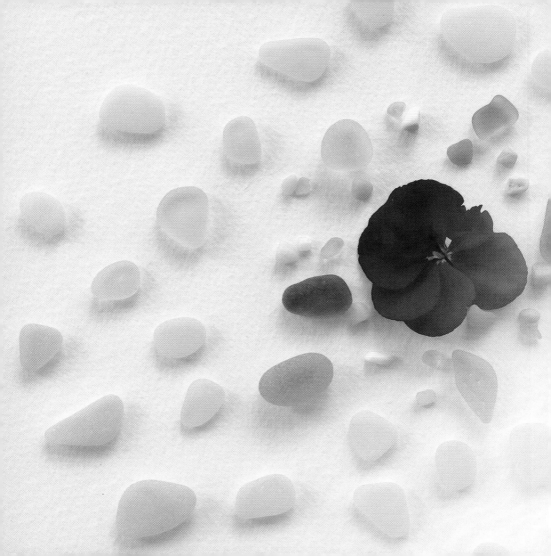

I understand how easy it would be to lose yourself in the heart of another. It's frightening. **Exhilarating.** An ocean with no lifeguard.

— Sarah Ockler, *Fixing Delilah*

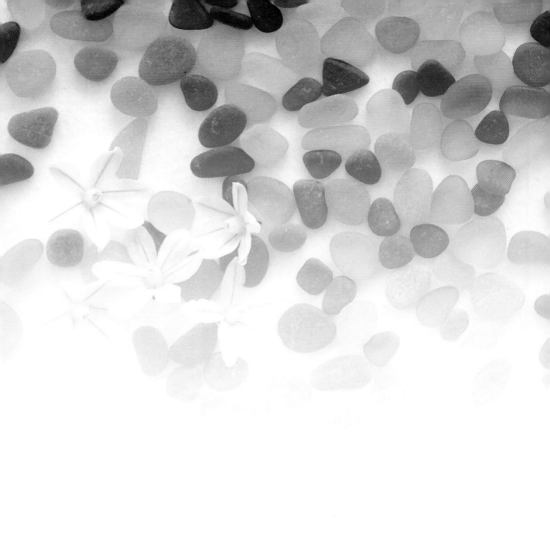

I imagine a line, a white line, painted on the sand and on the ocean, from me to you.

— Jonathan Safran Foer, *Everything Is Illuminated*

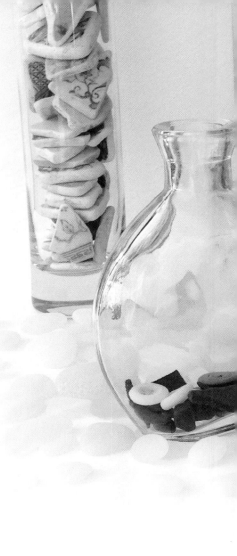

You are something
the whole universe is
doing in the same
way that the wave is
something that the
whole ocean is doing.

— Alan Wilson Watts, *The Real You*

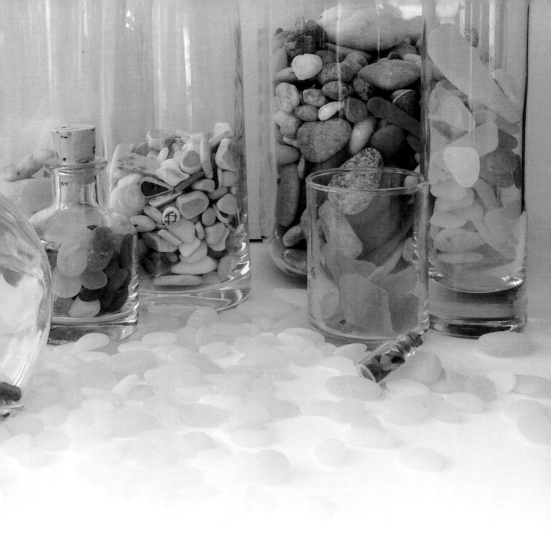

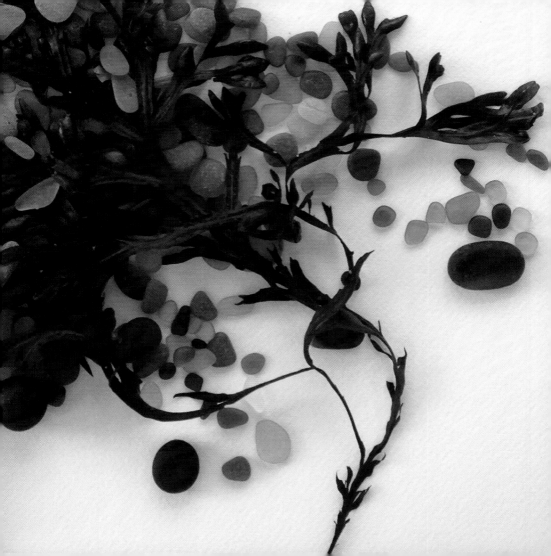

The sea is **emotion** incarnate. It loves, hates, and weeps. It defies all attempts to capture it with words and rejects all shackles. No matter what you say about it, there is always that which you can't.

— Christopher Paolini, *Eragon*

Patience, patience, patience, is what the sea teaches. Patience and faith. One should lie empty, open, choiceless as a beach — waiting for a gift from the sea.

— Anne Morrow Lindbergh, *Gift from the Sea*

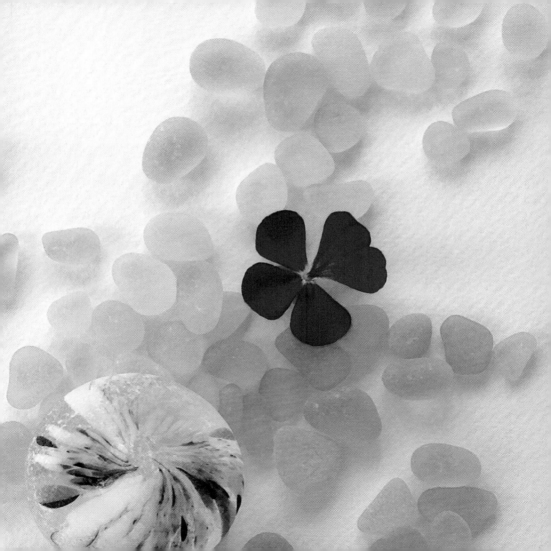

True love is **boundless** like the ocean and, swelling within one, spreads itself out and, crossing all boundaries and frontiers, envelops the whole world.

— Mahatma Gandhi, *Young India*

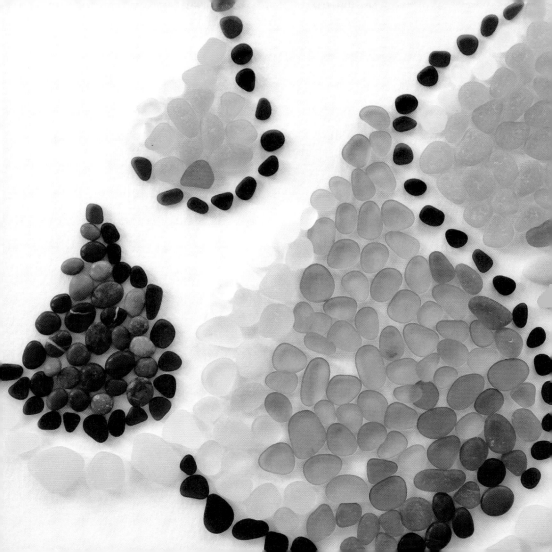

Exultation is the going
of an inland soul to sea.

— Emily Dickinson,
 #76, *Complete Poems of Emily Dickinson*

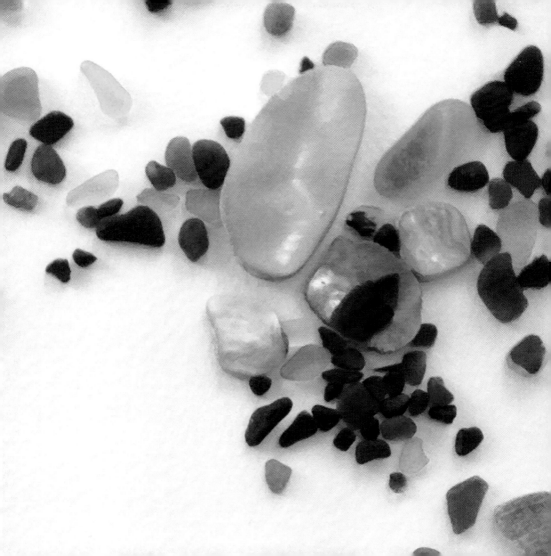

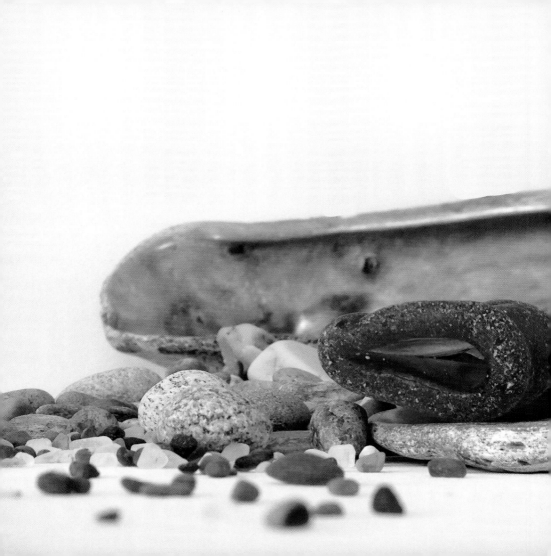

What we know is a drop,
what we don't know is an ocean.

— Sir Isaac Newton

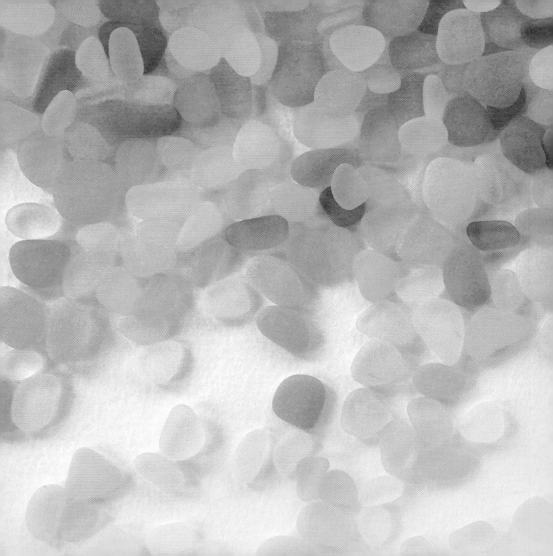

How inappropriate to call
this planet Earth, when
it is quite clearly Ocean.

— Arthur C. Clarke

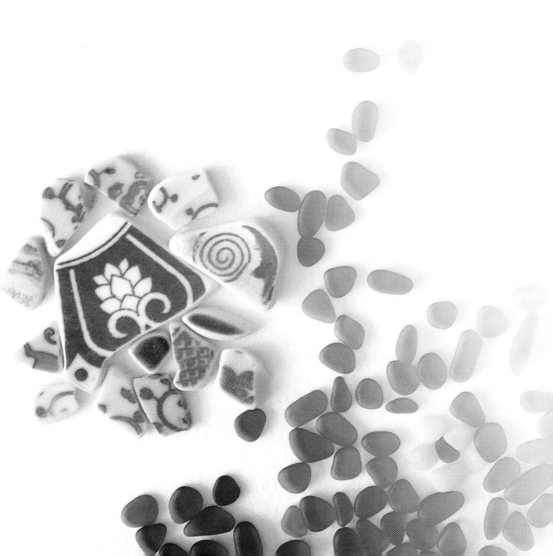

I will sleep no more but arise,
You oceans that have been calm
within me! How I feel you,
fathomless, stirring,
preparing unprecedented waves
and storms.

— Walt Whitman, *Leaves of Grass*

All know that the drop merges
into the ocean, but few know that
the ocean merges into the drop.

— Kabir

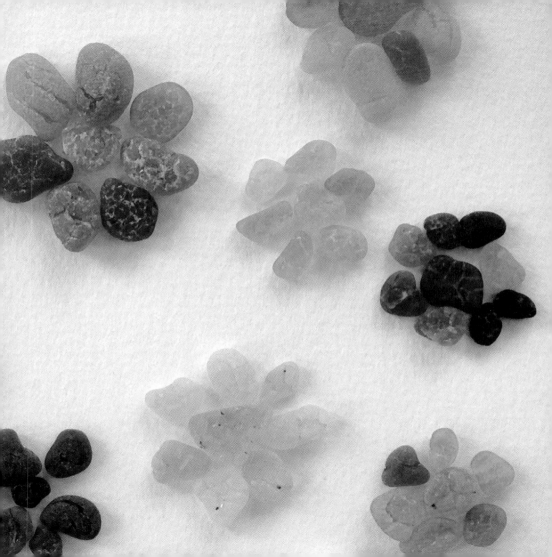

If rain drops were
kisses,
I'd send you showers.
If hugs were seas,
I'd send you oceans.
And if love was a person
I'd send you me!

— Emily Brontë

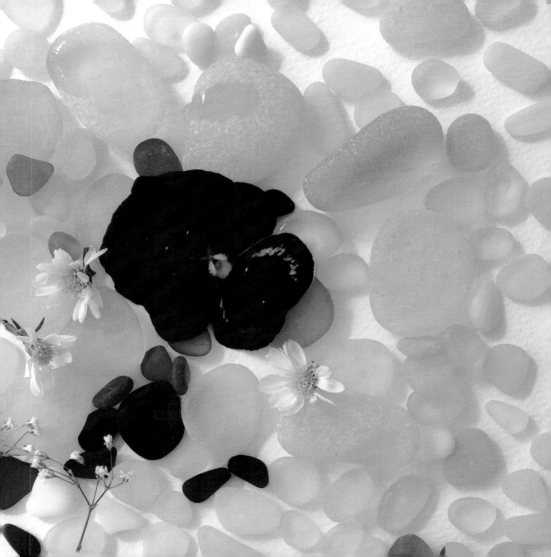

You only have to **forgive** once. To resent, you have to do it all day, every day.

— M.L. Stedman, *The Light Between Oceans*

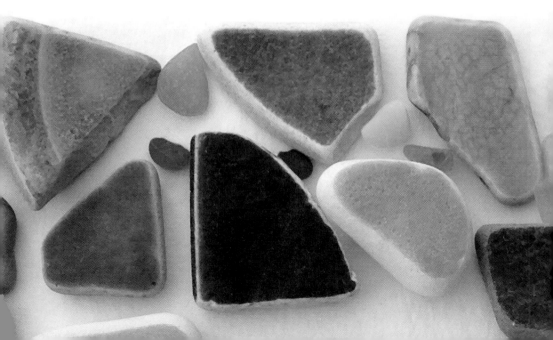

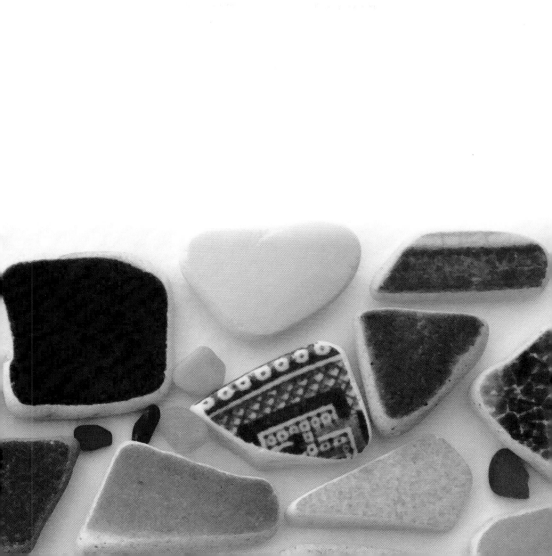

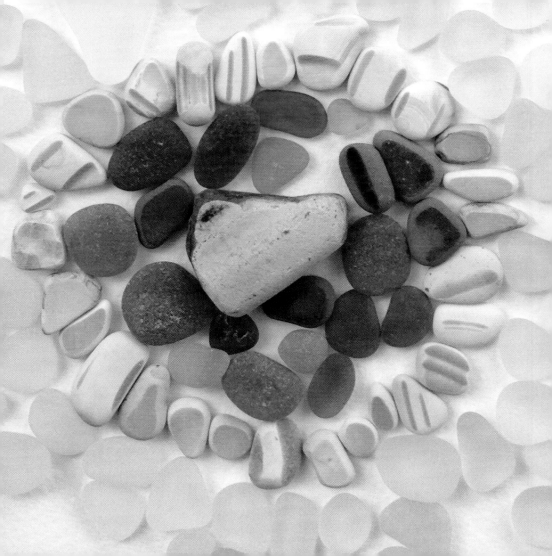

The heart can think of no **devotion**
Greater than being shore to the ocean—
Holding the curve of one position,
Counting an endless repetition.

— Robert Frost, *Devotion*

Might as well try to drink the ocean with a spoon as argue with a lover.

— Stephen King, *The Drawing of the Three*

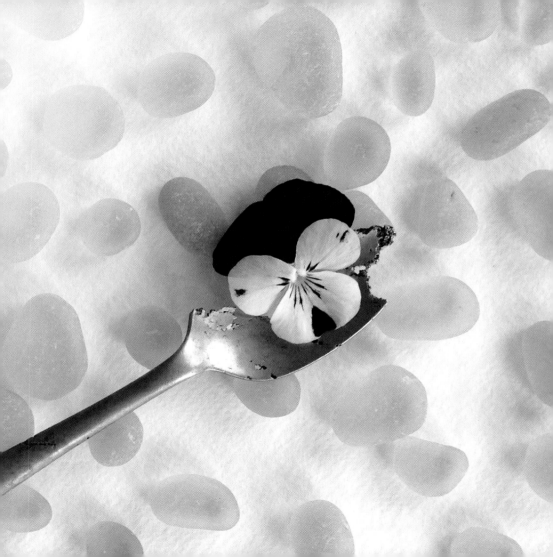

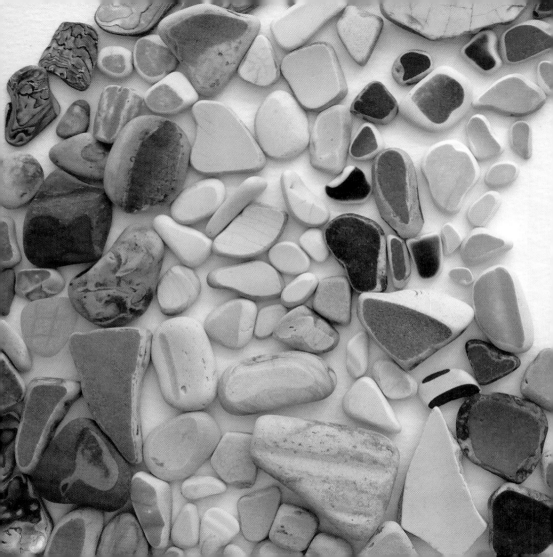

If you don't become the ocean, you'll be seasick every day.

— Leonard Cohen, *Good Advice for Someone Like Me*

It is easy to **believe** we are each waves and forget we are also the ocean.

— Jon J. Muth, *Zen Ties*

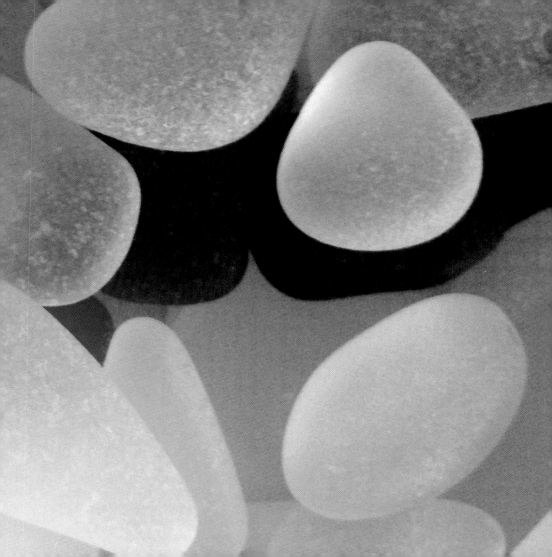

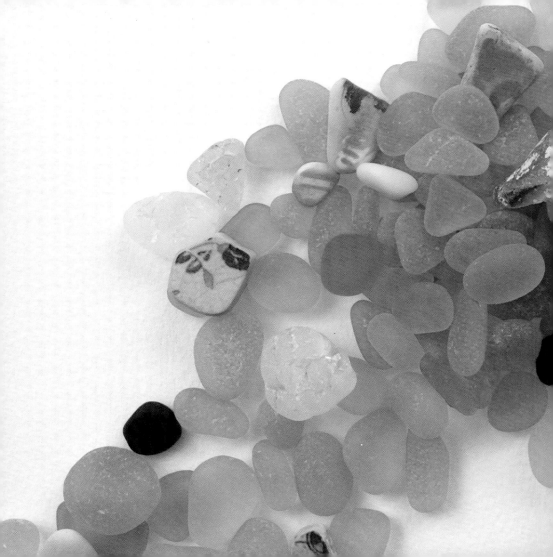

For ocean is more ancient than the mountains, and freighted with the memories and the dreams of Time.

— H.P. Lovecraft, *The White Ship*

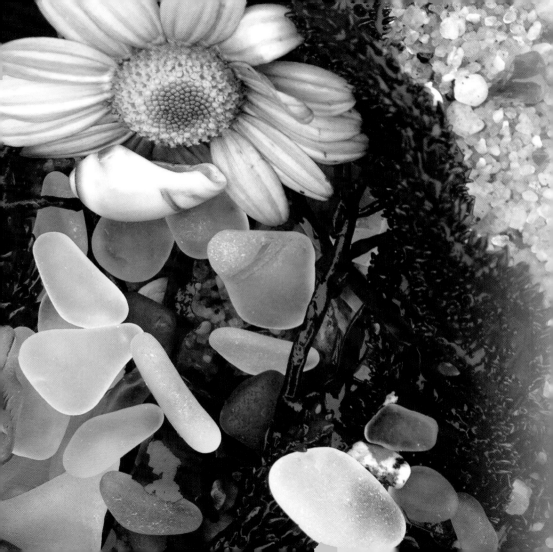

Now I know that our world is no more permanent than a wave rising on the ocean. Whatever our struggles and triumphs, however we may suffer them, all too soon they bleed into a wash, just like watery ink on paper.

— Arthur Golden, *Memoirs of a Geisha*

I've got a magic charm
That I keep up my sleeve,
I can walk the ocean floor
And never have to breathe.

— Maya Angelou, *Life Doesn't Frighten Me*

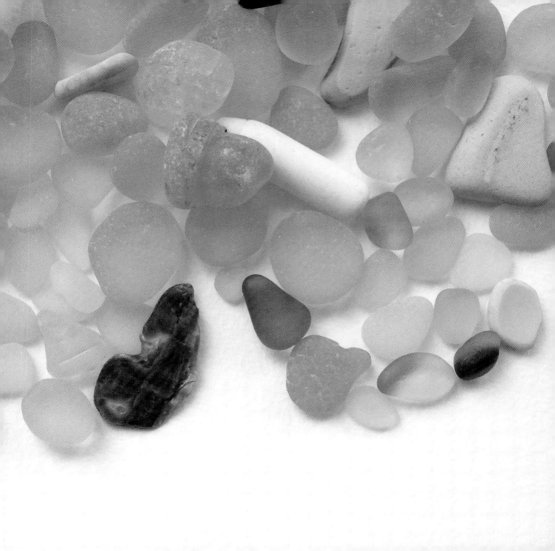

On life's vast ocean diversely we sail,
Reason the card, but
passion is the gale.

— Alexander Pope, *Essay on Man, Epistle II*

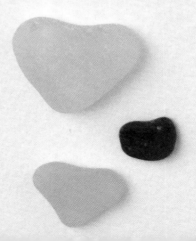

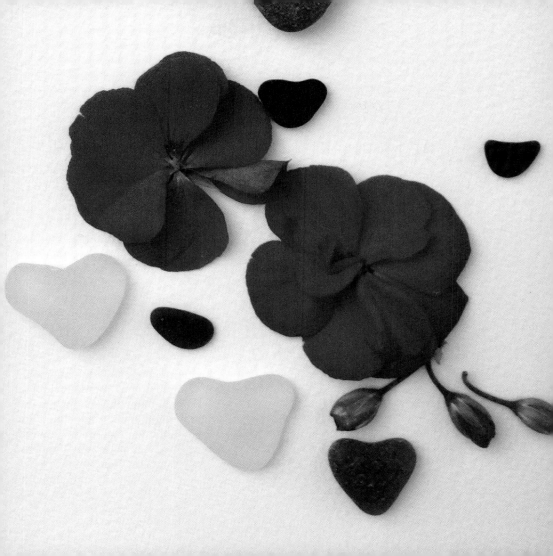

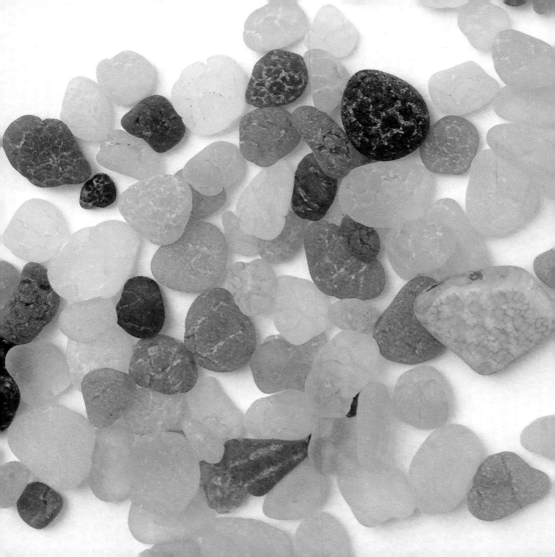

We are tied to the ocean. And when we go back to the sea, whether it is to sail or to watch, we are going back from whence we came.

— John F. Kennedy,
 from America's Cup Speech

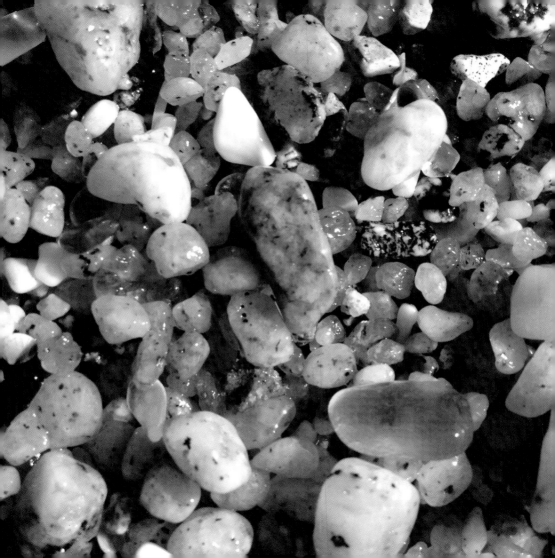

Some people could look at
a mud puddle and see an
ocean with ships.

— Zora Neale Hurston,
Their Eyes Were Watching God

My bounty is as boundless as
the sea, my love as deep;
the more I give to thee,
the more I have,
for both are infinite.

— William Shakespeare, *Romeo and Juliet*

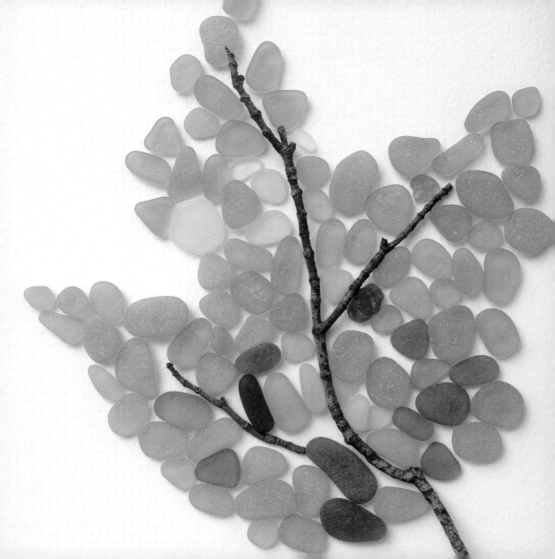

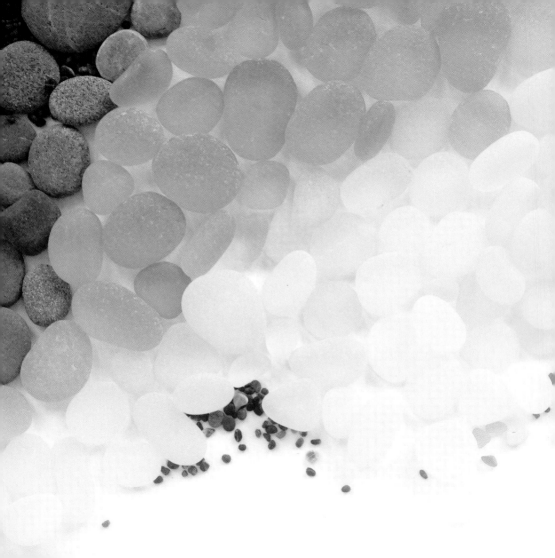

To measure you by your smallest deed is to reckon the ocean by the frailty of its foam. To judge you by your failures is to cast blame upon the seasons for their inconsistencies.

— Kahlil Gibran, *The Prophet*

...those who have been tossed on the stormy waters of the ocean on a few frail planks can alone realize the **blessings** of fair weather.

— Alexandre Dumas,
The Count of Monte Cristo

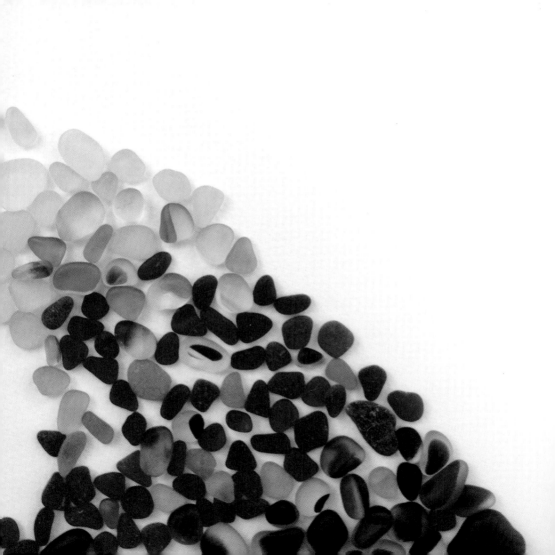

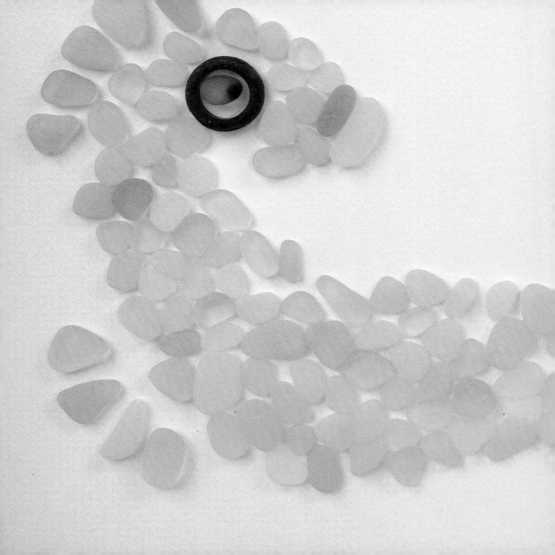

This is the
seashore.
Neither land
nor sea.
It's a place that
does not exist.

— Alessandro Baricco,
Ocean Sea

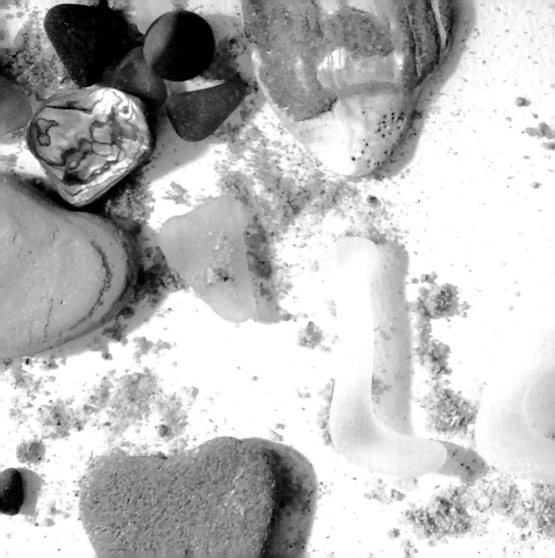

The ocean has been singing to me, and the song is that of our life together...

— Nicholas Sparks, *Message in a Bottle*

Donald Verger is a critically acclaimed, award-winning photographer.
He is the Founder and President Emeritus of The Children's Discovery Museum
and The Science Discovery Museum in Massachusetts. His photographs
are cherished and collected by people around the world.

Also Available

Donald Verger Photography calendars, birthday calendars, books, postcards
and prints can be found on Amazon.com and at your favorite retailer.

DonaldVerger.com
info@DonaldVerger.com